REMEMBER TO DREAM!

Hans. Ulrich Obrist

100 Artists

100 Notes

HENI PUBLISHING, LONDON

PREFACE

It was the late novelist, critic, philosopher and semiotician Umberto Eco who spoke to me about the significance of handwriting, professing his concern that we are on the verge of losing it as a great art. He told me that the art of handwriting teaches us to control our hands and relates to hand–eye coordination. It makes us compose the phrase mentally before writing it down. The resistance of pen and paper slows us down and makes us think.

The disappearance of handwriting is concurrent with the digital velocity that characterises our contemporary environment. The speed with which words and images are circulated throughout our globalised world can lead to a generalised state of homogeneity, whereby difference is flattened out and we are left with only the ubiquity of the typed word.

Eco's depiction of the (soon-to-be) lost art of handwriting was the starting point for my handwriting project on Instagram. It was intended as a conflation of analogue and digital; the slow composition of the written note and the velocity

of the Instagram post are brought together. This endeavour to record, remember and reaffirm the idiosyncrasy of handwriting began when Ryan Trecartin downloaded Instagram on my iPhone, whilst I was at his studio in Los Angeles. The overwhelming image potential that Instagram opened up prompted me to find a structure for its use. Like the gathering of French-speaking writers and mathematicians collectively known as Oulipo, who since 1960 have sought to create works using constrained writing techniques, I wanted to find a rule, my own constraint.

It was during a holiday with the artist–poet Etel Adnan, artist Simone Fattal and my partner, the artist Koo Jeong A, that this constraint became clear. On a stormy day, in a café, Etel was writing poems in a notepad, which I found incredibly beautiful. It soon became evident that the preset should be the written word – a celebration of handwriting rather than lamenting its disappearance. Since then, I have posted photographs of handwritten notes on Instagram once a day, each containing a message from individuals I meet.

It is fascinating that some handwritten sentences trigger an avalanche of comments, while others are not commented upon at all. I transcribe the handwritten sentences so that the typed sentence becomes the caption, like in a museum show. Writings in other languages are translated into English. The way the sentences are written is very often spontaneous, coming out of a conversation. Etel Adnan makes the connection with Eco: 'So Umberto is right. If we lose writing, we lose an enormous amount of meaning because writing like drawi ng, is an art. And we lose everything we have to say when we lose writing, because something written by hand says more than just words. It reflects a psychological state.'[1]

My handwriting project is an archive, a compendium of the handwritten form in the digital age. It shows beauty in the fact that human beings never have the same handwriting – at a time when there is a fear that globalisation is causing differences to disappear. Martinican writer, poet, philosopher and literary critic Édouard Glissant distinguishes between globality and globalisation. While globalisation eradicates differences and homogenises, globality is a global dialogue that produces differences.

The title of this book is taken from a Post-it written by artist Carrie Mae Weems in 2018. 'Remember to Dream!' speaks to the innate potential of idiosyncratic expression via the written word, and connects to the idea of mental composition through the act of thinking and imagining. As an ongoing and open process, my handwriting project not only captures moments of individual expression through the handwritten gesture, but it also celebrates and preserves difference; it is an archive of remembering.

1. Etel Adnan, interview with Hans Ulrich Obrist, February 2011

HANS ULRICH OBRIST

ARTISTS

1. Abloh, Virgil
2. Abramović, Marina
3. Adnan, Etel
4. Alechinsky, Pierre
5. Al-Maria, Sophia
6. Anderson, Laurie
7. Arca

8. Berners-Lee, Tim
9. Björk
10. Blondey
11. Boltanski, Christian
12. Boom, Irma
13. BTS
14. Buren, Daniel

15. Cao Fei
16. Chan, Paul
17. Chase-Riboud, Barbara
18. Cheng, Ian
19. Chicago, Judy
20. Clarke, Brian
21. Coupland, Douglas

22. Durham, Jimmie

23. Eco, Umberto
24. Eliasson, Olafur
25. Ellis, Bret Easton and Israel, Alex
26. Emin, Tracey
27. Eno, Brian

28. Fattal, Simone
29. FKA twigs
30. Fonda, Jane
31. Forti, Simone
32. Foster, Norman

33. Gates, Theaster
34. Gehry, Frank
35. Gibson, William
36. Gilbert & George
37. Gillick, Liam
38. Glass, Philip
39. Gonzalez-Foerster, Dominique
40. Goodall, Jane
41. Gordon, Douglas
42. Grigely, Joseph
43. Grimes

44. Hadid, Zaha
45. Hirst, Damien
46. Hockney, David
47. Höller, Carsten
48. Huang Yong Ping
49. Huyghe, Pierre

50. Jafa, Arthur

51. Kentridge, William
52. Kiefer, Anselm
53. Koo Jeong A
54. Koolhaas, Rem

55. Lee Ufan
56. Lucas, George

THE WORLD PRODUCES WAVES.

SURF OR DROWN.

YOU DECIDE.

VIRGIL

THE WORLD PRODUCES WAVES.
SURF OR DROWN.
YOU DECIDE.
VIRGIL
©2017

CLOUD iN THE SKY
DUST iN THE EYE

Marina Abramović

CLOUD IN THE SKY
DUST IN THE EYE

Marino Abramović

MARINA ABRAMOVIĆ

The world needs
Togetherness, not
separation. Love,
not suspicion.
A common future,
not isolation.

Etel Adnan

The world needs
Togetherness, not
separation. Love,
not suspicion.
A common future,
not isolation.

ETEL ADNAN

ETEL ADNAN

To write

with both

hands

at the

same time

4

Écrire ... des deux mains ... en même ... temps

PIERRE ALECHINSKY

ETERNITY

GUIDE

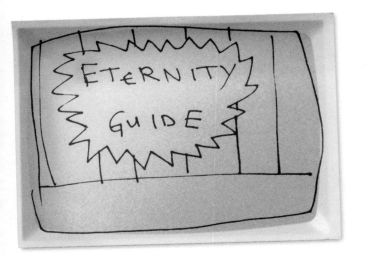

SOPHIA AL-MARIA

← →

VIRUS IS A

LANGUAGE

(*ON*
GOING VIRAL]

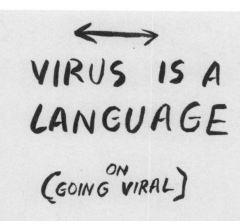

LAURIE ANDERSON

to
softness
as a
weapon
when the
mind
attacks
itself.
- Arca

to softness
as a weapon
when the
hard attacks
itself.

—Arca

ARCA

This is is

for

everyone

Tim BL

8

This is for everyone

TIM BERNERS-LEE

my sku*ll*
is my
cathedra*l*

my skull
is my
cathedral

BJÖRK

'J' is for Jupiter (the bringer of jollity).

BLONDEY

CHRistiAN BOLTANSKi

TAKE

ME

CHRISTIAN BOLTANSKI

Books

can't

get enough!

IRMA BOOM

Books
can't
get enough!

IRMA BOOM

IRMA BOOM

Music — Art

You — Me — Us

음악 - 미술

너 - 나 - 우리

BTS

The pitcher will
go to the well once
too often and will
end up broken!
La Fontaine

coming soon

15

NO TO BOUNDS BY
GENDER

NO TO CLICKBAIT AS
CULTURE

NO TO NEWS AS TRUTHS

NO TO ART AS UNTRUTHS

16

No to BOUNDS BY
GENDER

No to CLICKBAIT AS
CULTURE

No to NEWS AS TRUTHS

No to ART AS UNTRUTHS

PAUL CHAN

BARBARA CHASE-RIBOUD

R.I.P.
EMAIL
1971 – 2020

IAN CHENG

One of the most intimate

relationships of my

life is my hand draw-
ing or writing on
paper, which is becom-

ing (SADLY) a LOST

ART!

Judy Chicago

One of the most intimate
relationships of my
life is my hand draw-
ing or writing on
paper, which is becom-
ing (SADLY) a LOST
ART!

Judy Chicago

JUDY CHICAGO

To be an artist
you have to be
prepared to abandon
everything you believe
when you discover a
new truth.

BrianClarke

To be an artist
you have to be
prepared to abandon
everything you believe
when you discover a
new truth.

Brian Clarke

BRIAN CLARKE

I'm starting

to forget

what my

pre-Internet

 brain
 felt

 like.

 D C

21

I'm starting to " forget what my pre-Internet brain felt like.

DOUGLAS COUPLAND

Humanity is not a completed

project.

Jimmie Durham

Humanity is not a completed
project.

 Jimmie Durham

||||||||

JIMMIE DURHAM

But can we still
write by hand?
I don't know.
Let me check.

Umberto Eco

23

Ma si se scrivere
ancora a mano?
Non so.
Adesso controllo —

Umberto Eco (signature)

① 10 words
guiding the
commitment
to a better
climate :

THE
10 C's

WORK IN
PROGRESS

② BE CLiMATE

⑨ BE COMPASSiONATE

③ BE CALM

⑩ BE CONFIDENT

④ BE CLEAR

⑤ BE COURAGEOUS

Olafur Eliasson
(with Hans U. Obrist)
springtime 2020

⑥ BE CONNECTED

⑦ BE CREATiVE

⑧ BE COMMiTTED

24

Note: Olafur Eliasson's 10 C's are based on
Richard Schwartz's 8 C's of Self Leadership

① 10 words guiding the commitment to a better Climate:

THE 10 C's
WORK IN PROCESS

② BE CLIMATE

③ BE CALM

④ BE CLEAR

⑤ BE COURAGEOUS

⑥ BE CONNECTED

⑦ BE CREATIVE

⑧ BE COMMITTED

⑨ BE COMPASSIONATE

⑩ BE CONFIDENT

(with Hans U. Obrist)
spring/summer 2020

OLAFUR ELIASSON

WE TOOK VIAGRA AND
LISTENED TO "THE DARK SIDE
OF THE MOON" WHILE TRYING
TO FORGET THE WORST YEAR IN
HISTORY HAD JUST BEGUN.

Bret Easton Ellis Alex Israel

25

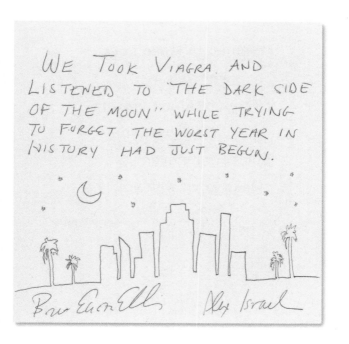

WE TOOK VIAGRA. AND LISTENED TO "THE DARK SIDE OF THE MOON" WHILE TRYING TO FORGET THE WORST YEAR IN HISTORY HAD JUST BEGUN.

BRET EASTON ELLIS AND ALEX ISRAEL

I wanted to Make Love

with you –

I Thought About making

Love with you –

But – I will never

Make Love with you.

Tracey Emin

26

I wanted to Make Love
with you —
I thought About making
Love with you —
But — I will never
Make Love with you.
X Tracey Emin

TRACEY EMIN

Make in your Art

what you want

in your Life.

B.E.

27

Make in your Art
what you want
in your Life.

B.E.

Yesterday Saw the

New Moon

This morning

the Sun is

shining

Time Runs

around Simone

28

yesterday Saw the
 New Moon
This morning
the Sun is
 shining
Time Runs
 around Simone

SIMONE FATTAL

Im a sweet little

love maker .

FKA
twigs
X

FKA TWIGS

it's more
important to be
interested than
to be
interesting

Jane Fonda

it's more
important to be
interested than
to be
interesting
Jane Fonda

JANE FONDA

How beautiful , the word

on the page.

Simone Forti
2/2/14

How beautiful, the word
on the page.

Simone Forti
2/2/14

SIMONE FORTI

THE FOSTER FAMILY MOTTO

THE ONLY CONSTANT IS CHANGE

Norman Foster
28⁄12⁄18
Engadine Valley

THE FOSTER FAMILY MOTTO

THE ONLY CONSTANT
IS CHANGE

NORMAN FOSTER
28 / 12 / 18
ENGADINE VALLEY

THEASTER GATES

IF ARCHITECTURE IS FROZEN
MUSIC .

IS MUSIC LIQUID
 ARCHITECTURE ?

FRANK GEHRY

34

IF ARCHITECTURE IS FROZEN
MUSIC .

IS MUSIC LIQUID
ARCHITECTURE ?
.

FRANK GEHRY

FRANK GEHRY

UNEVENLY DISTRIBUTED

WM. GIBSON

UNEVENLY DISTRIBUTED

*

WM. GIBSON

WILLIAM GIBSON

Gilbert + George said -:

To Be With Art is all we ask...

1970

Gilbert + George said-:
To Be With Art is all we ask...
1970

GILBERT & GEORGE

HOW CAN
QUANTUM
 GRAVITY
EXPLAIN THE
 ORIGIN OF
 THE
 UNIVERSE?

Liam 2019

37

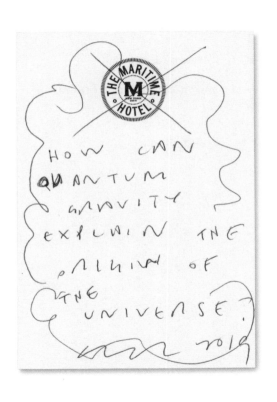

LIAM GILLICK

I dream of music

and in my music, I dream.

Philip Glass

I dream of music
and in my music, I dream.

Philip Glass (signature)

PHILIP GLASS

IT'S NOT THE WAY
YOU ARE MOVING
IT'S WHAT
IS MOVING YOU

39

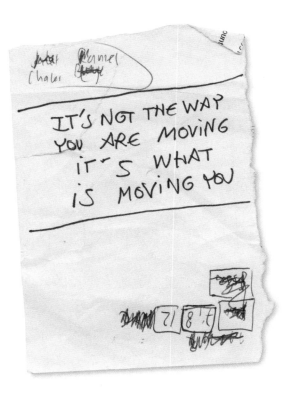

IT'S NOT THE WAY
YOU ARE MOVING
IT'S WHAT
IS MOVING YOU

DOMINIQUE GONZALEZ-FOERSTER

Together we can make this a better
world for all

Jane Goodall

Jane Goodall, PhD, DBE Founder –
the Jane Goodall Institute & UN Messenger of Peace

Together we can make this a better world for all

Jane Goodall

JANE GOODALL

UPITOA

DOUGLAS GORDON

It's like hearing
what your
 pencil
 will tell

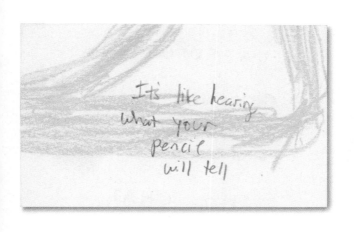

It's like hearing
what your
pencil
will tell

JOSEPH GRIGELY

" A PROFOUND

SILENCE HAS

ENTERED

THE CHAT "

×

– GRIMES

"A PROFOUND
SILENCE HAS

ENTERED
THE CHAT"

-GRIMES→

I Think There should
be No end to
Experimentation

Zaha Hadid

I Think There should
be No end to
Experimentation

ZAHA HADID

I want to
LIVE
FOREVER
(for A while)

Damien Hirst

I want to
LIVE
FOREVER
(for A while)

Damien [signature]

DAMIEN HIRST

Love Life

David

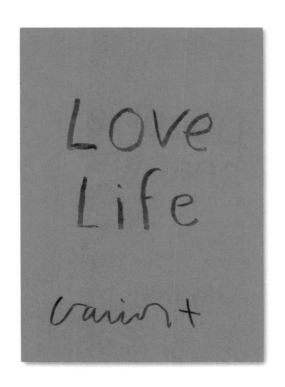

DAVID HOCKNEY

Doubt is beautiful

Carsten

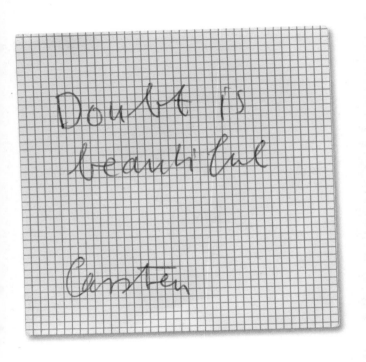

CARSTEN HÖLLER

FO
RG
ET

Huang Yong Ping

48

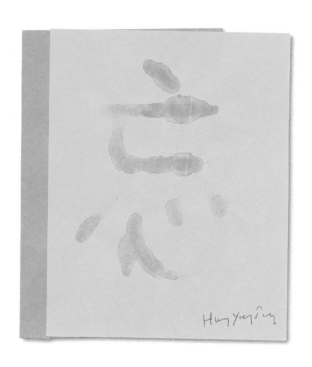

HUANG YONG PING

CONTiNUOUS

LEAK ...

CONTINUOUS
LEAK ...

PIERRE HUYGHE

LESS

is

Morbid

Arthur JAFA

LESS

is

Morbid

[signature]

ARTHUR JAFA

Art is the fundamental

resistance to Entropy

Art is a fundamental
resistance to Entropy

WILLIAM KENTRIDGE

We see the future with eyes
shaped in childhood.
Anselm Kiefer

Wir sehen die Zukunft mit
dem in der Kindheit geformten
Auge

Anselm Kiefer

ANSELM KIEFER

KOO JEONG A

SOMETIMES, THE EXPERIENCE
OF BEING TRANSLATED/TRANS
FORMED BY A GOOD INTER-
PRETER IS ALMOST SENSU-
AL, YOU WITNESS A BETTER
VERSION OF YOURSELF...
THIRLWELL'S PROLIFERA-
TION OF AUTHORS AND
THEIR INTERPRETERS
WILL GENERATE A
REVERSE BABEL OF A
MOVING, UNIVERSAL
UNDERSTANDING, I
THINK...

SOMETIMES, THE EXPERIENCE
OF BEING TRANSLATED/TRANS
FORMED BY A GOOD INTER-
PRETER IS ALMOST SENSU-
AL, YOU WITNESS A BETTER
VERSION OF YOURSELF...
THIRLWELL'S PROLIFERA-
TION OF AUTHORS AND
THEIR INTERPRETERS
WILL GENERATE A
REVERSE BABEL OF A
MOVING, UNIVERSAL
UNDERSTANDING, I
THINK....

REM KOOLHAAS

art is

an astonishing encounter

17.4.22

Lee Ufan

예술은
신기한 만남이다

'17. 4. 22
이 우환
LeeUfan

LEE UFAN

May the force be with
you!

GL

May the f ce be with
you!

GEORGE LUCAS

Keep your eye on

the donut

and not on the

hole. —

David Lynch

. . . .

keep your eye on
the donut
and not on the
hole. *[signature]*

DAVID LYNCH

« The civilisation of
tomorrow is
the sum of
marginalities »

Alain Mabanckou

« La civilisation de
demain sera
celle de l'addition
des marginalités »

Alain Mabanckou

ALAIN MABANCKOU

You were only

waiting
 For this moment
To A R I S E.

P McCartney

———

You were only
waiting
For this moment
To ARISE.

[signature]

PAUL McCARTNEY

Remember me

60

Remember me

STEVE McQUEEN

I carry

my
places with

me

Jonas

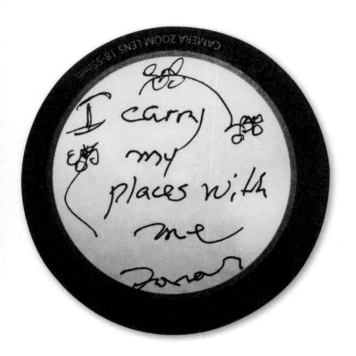

JONAS MEKAS

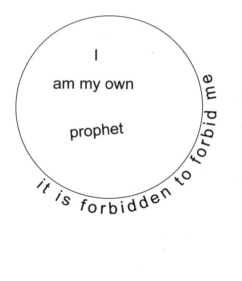

I

am my own

prophet

it is forbidden to forbid me

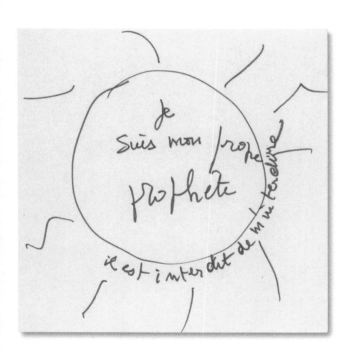

ANNETTE MESSAGER

remember Nature

63

remember Nature

GUSTAV METZGER

PROTECT

YOUR

REFUSAL

64

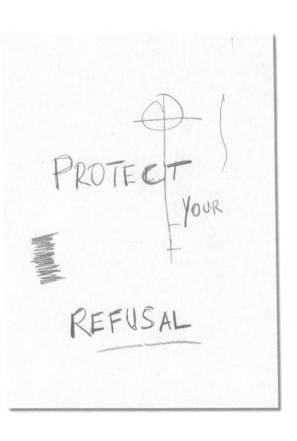

JOTA MOMBAÇA

In the studio there is
no time.
All history is
the present and the
present is
history.

Im Atelier gibt es
keine Zeit.
Alle Geschichte ist
Gegenwart und alle
Gegenwart ist
Geschichte.

SABINE MORITZ

Do I get to write anything I want ?

— Fred Moten

So I get to write anything I want?

—Fred Moten

FRED MOTEN

POETRY

IS A

MOVING

SPACE.

E.

POETRY

IS A

MOVING

SPACE.

☺

EILEEN MYLES

Can Art be a Weapon

for change?

آیا هنری توانه سلاحی برای

تغییر باشو؟

Can Art be a Weapon
for Change?

SHIRIN NESHAT

KEEP

DREAMING

69

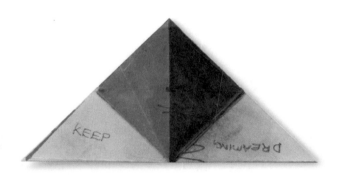

OTOBONG NKANGA

Memo

Write from
the deepest
well within
you. Edna O'Brien

70

Thou Shalt

Memo

Write from
the deepest
well within.
You. Edna O'Brien

EDNA O'BRIEN

I FEEL
LIKE CRYING
BUT..
I CAN'T
I THINK
I BROKE IT.

Frank

I FEEL LIKE CRYING BUT.. I CAN'T I THINK I BROKE IT.

Frank

FRANK OCEAN

what

 does

a world

without fear

look like?

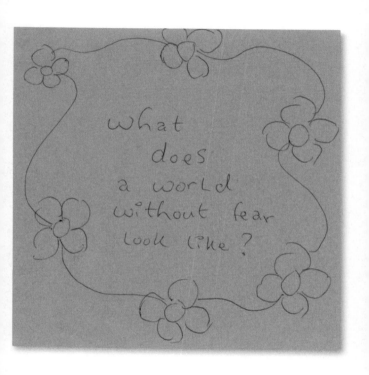

what
does
a world
without fear
look like?

PRECIOUS OKOYOMON

Time To Tell Your Love
YO. '13

Pixie To Tell Your Love

40. '13

YOKO ONO

till memory is no more

I feel certain that people
will always be interested in
archaeology in general and
the archaeology of Cyprus in
particular. It is in the human
nature to learn and find
out what happened in the
past and there is particular
fascination in trying to do so,
even for people who are not
archaeologists. My hope is
that the archaeologists of the
future will profit from the
possibilities which are offered
by modern technologies
for the interpretation of the
past.

Vassos Karageorghis

Christodoulos Panayiotou

74

I feel certain that people will always be interested in archaeology in general and the archaeology of Cyprus in particular. It is in the human nature to learn and find out what happened in the past and there is particular fascination in trying to do so, even for people who are not archaeologists. My hope is that the archaeologists of the future will profit from the possibilities which are offered by modern technologies for the interpretation of the past.

Vassos Karageorghis

till memory is no more

Christodoulos Panayiotou

CHRISTODOULOS PANAYIOTOU
AND VASSOS KARAGEORGHIS

"MOVED WITHOUT MOTION"

PARRENO

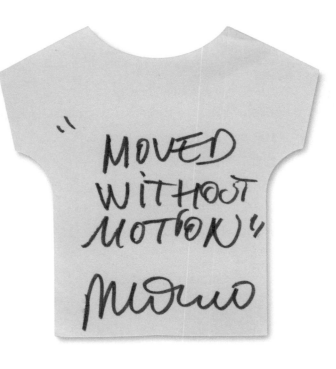

PHILIPPE PARRENO

I feel the forest
breathing and hear
the slow, inexorable
growth of the wood;
I match my breathing
to that of the green
world around me

Giuseppe Penone

Sento il respiro della
foresta, odo la crescita
lenta ed inesorabile del
legno, modello il suo
respiro nel respiro del
vegetale

Giuseppe Penone

GIUSEPPE PENONE

Com-a-com-

a - rrade...

What does black radicality lookalike to you?????

77

SONDRA PERRY

(smile). ☺

Raymond Pettibon ☺

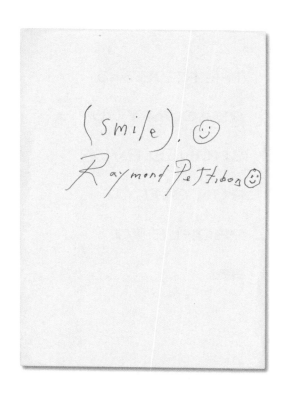

RAYMOND PETTIBON

THERE IS NO

REASON YOU

SHOULD EVER

RUN OUT OF

PEOPLE TO

BE

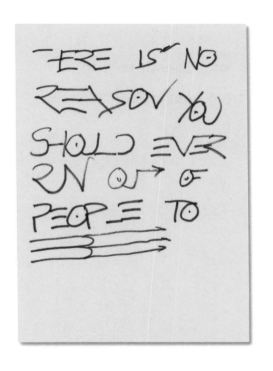

THERE IS NO
REASON YOU
SHOULD EVER
RUN OUT OF
PEOPLE TO

GENESIS P-ORRIDGE

How long does it take to

get from ecstasy to

epiphany?

Raqs

How long does it take to
get from ecstasy to
 epiphany?

 Rags

RAQS MEDIA COLLECTIVE

Art is the
highest form
of hope —

Gerhard Richter.

Kunst ist die
höchste Form
von Hoffnung —
Gerhard Richter.

GERHARD RICHTER

Anyone Can Fly

all you gotta do is try

To the White House
 Women

 let's go!

Faith Ringgold
6/6/19

82

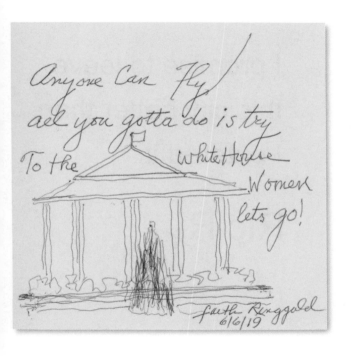

FAITH RINGGOLD

I promise to leave this city better than I entered it.

Ric R$_x$

I promise to leave
this city better than
I entered it.

Richard Rogers

RICHARD ROGERS

WE ARE NOT

MEAN T
F OR
EAR TH

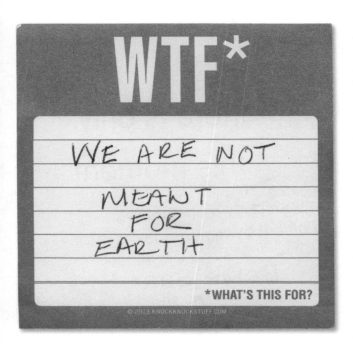

WTF*

WE ARE NOT

MEANT
FOR
EARTH

*WHAT'S THIS FOR?

© 2013 KNOCKKNOCKSTUFF.COM

RACHEL ROSE

Today,

there is only,

this moment –

(moment by moment by
moment by moment to ...

Betye Saar

7 - 30 – 17

To.day—
there is only
this moment—
moment by moment by
moment by moment b:.
Betye Saar
7.30-17

BETYE SAAR

THE MUSEUM
OF THE FUTURE
IS A POCKET
MUSEUM.

THE MUSEUM OF THE FUTURE IS A POCKET MUSEUM.

Museum Bhavan

DAYANITA SINGH

Zadie Smith

The question is:
How to live the time of
your life – the intimate time
of your life – alongside the
time of history. Which should
you devote yourself to? Which deserves
your attention? Which is real?

The question is: *Zadie ?*
How to live the time of
your life – the intimate time
of your life – alongside the
time of history. Which should
you devote yourself to?, which deserves
your attention? which is real?

ZADIE SMITH

We are

all

implicated

P Staff

we are
all
implicated

P Staff

P. STAFF

FEAR EATS THE SOUL

FEAR
EATS
THE
SOUL

RIRKRIT TIRAVANIJA

A day
without seeing a tree
is a waste of a day.

Agnès Varda

un jour
sans voir un arbre
est un jour foutu

Agnès Varda

AGNÈS VARDA

It's forbidden to forbid

Caetano.

É proibido proibir

Caetano

CAETANO VELOSO

CECILIA VICUÑA

TODAY

WE

REBOOT

THE

PLANET

TODAY

WE

REBOOT

THE

PLANET

ADRIÁN VILLAR ROJAS

Remember To Dream !

Carrie Mae Weems

Remember To
Dream !

Carrie Mae Weems

CARRIE MAE WEEMS

REALITY ADJACENT TO UTOPIA

REALITY ADJACENT TO UTOPIA

LAWRENCE WEINER

The acorn is happy to
become an oak.

 Aristotle.

He defines happiness as fulfilling

yr. potential.

 Follow yr. deep interest
(forget y'self) & become

 who U R.

 Vivienne

The acorn is happy to
become an oak.
 Aristotle.

He defines happiness as fulfilling.
yr. potential.

 Follow yr deep interest
(forget y'self) + become
 who U R.

 Vivienne 🖤

VIVIENNE WESTWOOD

"
My story is in

the paint "

Jack Whitten

"My story is in
the paint"

Jack Whitten

THE CLOSEST THING
TO THE 4TH
 DIMENSION IS WHEN
WE CLOSE OUR EYES
& LOOK
 NO TIME , NO SPACE
 JUST YOU P.W.

THE CLOSEST THING
TO THE 4TH
DIMENSION IS WHEN
WE CLOSE OUR EYES
& LOOK....
NO TIME, NO SPACE
JUST YOU... P.W.

PHARRELL WILLIAMS

Make It

Happen .

(All Of It !)

(Every Time !)

(Regardless)

Make It
Happen.
(All of It!)
(Every Time!)
(Regardless....)

LYNETTE YIADOM-BOAKYE

This is an aliens' land,
how long can I wander
O my pained heart what to do,
O my savage heart what to do

Majaz

———

غیروں کی بستی بیٹھے کب تک دربدر مارا
پھروں - نمبر دل کیا کروں اسے مہنتذرم
کیا کروں .

بھگاز

ZARINA

This publication is thanks to HENI Publishing and my friend Joe Hage, who first had the idea to realise this book, and to its designer Irma Boom, who designed our book *Project Japan: Metabolism Talks* with Rem Koolhaas. I am delighted that this new project has come to fruition. Thank you to all the artists who participated in the handwriting project.

© 2023 HENI Publishing

All notes © the contributors
Preface text © 2023 Hans Ulrich Obrist
Photo (p.5) © Lukas Wassmann

ISBN 978-1-912122-07-3

Designed by Irma Boom

Printed in Italy by Graphicom

MIX
Paper | Supporting
responsible forestry
FSC® C013123